APERTURE MASTERS OF PHOTOGRAPHY

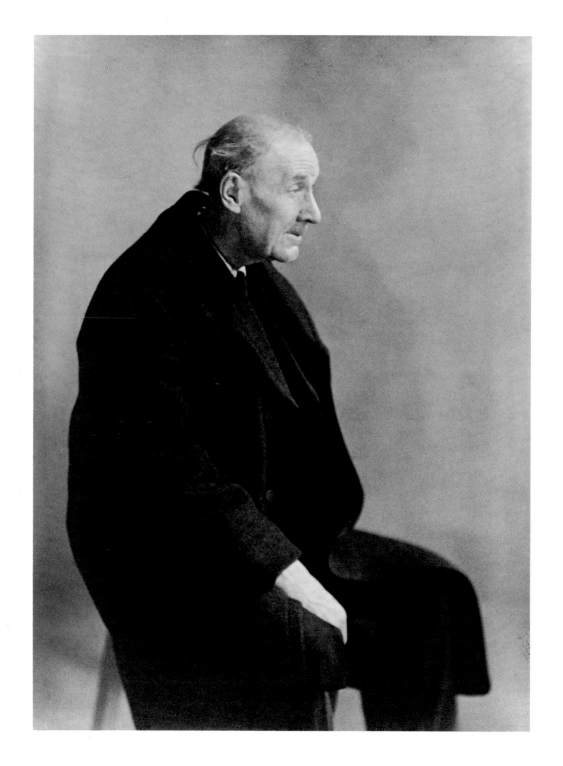

EUGÈNE ATGET

With an Essay by Ben Lifson

MASTERS OF PHOTOGRAPHY

APERTURE

Frontispiece: Eugène Atget by Berenice Abbott, Philadelphia Museum of Art

The photographs in this volume have been kindly loaned by the Philadelphia Museum of Art, Graphics International Ltd., and the Arnold H. Crane Collection.

Printed and bound in Hong Kong.
Library of Congress Catalog Number: 79-56746
ISBN: 0-89381-750-3

This 1997 edition is a coproduction of Könemann Verlags Gmbh
and Aperture Foundation, Inc.

Aperture Foundation publishes a periodical, books, and portfolios of fine photography to communicate with photographers and creative people everywhere. A complete catalog is available upon request. Address: 20 East 23rd Street, New York, New York 10010. Phone: (212) 598-4205. Fax: (212) 598-4015.

The Aperture Masters of Photography series is distributed in the following territories through Könemann Verlags Gmbh, Bonner Str. 126, D-50968 Köln. Phone: (0221) 93 70 39-0. Fax: (0221) 93 70 39-9: *Continental Europe, Israel, Australia, and the Pacific Rim.* The series is distributed in the following territories through Aperture: *Canada:* General Publishing, 30 Lesmill Road, Don Mills, Ontario, M3B 2T6. Fax: (416) 445-5991. *United Kingdom:* Robert Hale, Ltd., Clerkenwell House, 45-47 Clerkenwell Green, London EC1R OHT. Fax: 171-490-4958. *All other territories:* Aperture, 20 East 23rd Street, New York, New York 10010. Phone: (212) 505-5555. Fax: (212) 979-7759.

For international magazine subscription orders for the periodical *Aperture*, contact Aperture International Subscription Service, P.O. Box 14, Harold Hill, Romford, RM3 8EQ, England. Fax: 1-708-372-046. One year: £30.00. Price subject to change.

To subscribe to the periodical *Aperture* in the U.S.A. write Aperture, P.O. Box 3000, Denville, NJ 07834. Phone: 1-800-783-4903. One year $40.00.

K 2 K4 K6 K8 K7 K5 K3 K1

On August 3, 1927, the day before his death, Eugène Atget struggled to the balcony of his sixth-floor apartment at 17 bis Rue Campagne Premier, Montparnasse, looked down at Paris and shouted, "I'm dying!" A fitting gesture for an ex-actor; an unintentionally comic one for an unrecognized genius; a tardy self-dramatization for a recluse in a city of flamboyant artists — but a tragic farewell to the Paris he had loved and photographed for twenty-nine years.

Atget photographed Paris obsessively, getting up before dawn, day after day, to be in the streets with the first morning light. He lugged a bulky wooden view camera, a tripod, and glass negatives in heavy wooden holders — almost forty pounds worth of equipment — through the city; into the surrounding countryside; and often as far as Versailles and Saint-Cloud. He usually photographed until noon, then returned home to process and print his day's work. This routine lasted from 1898, when Atget began his epic work, until World War I, when failing health and growing depression slowed him down. But he kept on working, and at the end of his life he was a picturesque figure with shabby work clothes, antiquated equipment, and the large black cloth he would drape over himself and his camera whenever he took a picture. Young artists in Montparnasse called him "Le Père Atget."

Old Atget, Humble Atget, Father Atget, however you translate it, he wasn't — as some critics would still have it — simple Atget. He was a well-educated man, a sophisticated artist. His photographs — unparalleled in their lucid realism and their lyrical response to the living pulse of a city; to artifacts that speak of human life in almost every social class; and to the early morning light he loved so faithfully — are among the most complex images ever made with a camera. Atget's work, which some historians estimate at 10,000 photographs, is like a skein of different colored threads. He describes each without isolating one from another, and weaves and reweaves them into a seemingly infinite number of combinations.

Complexity, multiplicity, even contradiction — these themes at the heart of Atget's work are not just intellectual ideas or artistic principles; for Atget, they were the stuff of experience itself.

Orphaned early and reared by an uncle, he knew about loss and partial renewal before his adolescence. Born in the port city of Bordeaux in 1857, his early years were colored by both the surrounding countryside and the sea. There is some evidence that Atget's uncle — a successful bureaucrat with the national railway system — moved the family to Paris by the 1860s, and, intending the boy for the priesthood, enrolled him in a better-than-average Catholic high school. If this is true, by the time Atget was a young man, he had experienced the capital as well as the provinces, had studied the classics, church Latin and theology.

We do know that he first decided on a career at sea, and with this choice the wanderings of his young adulthood began. He sailed to Uruguay as a cabin boy on a merchant ship, and then abandoned the notion of a sailor's life. Back in Paris in 1879, aged twenty-two, he enrolled in the Conservatory of the French National Theatre and studied acting. His interest in classical mythology and European history may have begun there, while learning the neoclassical drama of Racine, and the historical plays of nineteenth century romantic French theatre. In 1881 Atget left the conservatory, and for the next seventeen years acted in the provinces, crisscrossing France with various touring companies. He had little success as an actor. Not a handsome man, he was typecast in character roles; and in 1898 he left the theatre in defeat. However, his desire to be an artist was undiminished.

He now had two problems: to earn a living, and to find a new artistic medium. He tried painting, failed, and turned to photography. In 1899 he discovered a market for documentary photographs of Old Paris and sold 100 prints to the Historical Library of Paris. Soon other historical institutions and private collectors also began buying his work. The painters he had studied with bought his picturesque work as source material for their canvases, and the sign outside Atget's apartment-studio read, "Documents pour Artistes." Georges Braque, Maurice de Vlaminck, Maurice Utrillo, Henri Matisse, and Man Ray were among his customers. Although he didn't find a large audience and never exhibited during his lifetime, he earned a living at photography. After 1899, Atget never changed his métier again.

His spirit was nurtured by diversity, but his mind sought connection. In a photograph taken at Versailles (cover), a bronze mermaid in a reflecting pool seems to awaken, startled by the storm clouds in the sky above the palace. Because the clouds seem the cause of the mermaid's fear, Atget animates two mythological worlds: classical mythology — cosmic, psychological, and ornamental; and the political myth of Versailles, seat of the Sun King — hierarchical, propagandistic, and functional. He also creates a fiction of his own — beautiful, democratic, and visionary — a bronze mermaid awakened by a storm in a public park.* This complex, imaginative understanding of a simple scene wasn't at odds with Atget's practical, commercial reasons for photographing Versailles. To his mind,

*This is the only instance we know where Atget, whose negatives were extremely sensitive to blue light, took the pains to print in sky detail.

the production of photographs about old French culture for a specific market was also an occasion for making art.

Two letters Atget wrote in 1920 to Paul Léon, director of the Beaux-Arts, allude to the dual nature of his work. Concerned about the survival of his pictures, Atget characterizes them and asserts their value:

"I have amassed, over more than twenty years, by my work and individual initiative, in all the old streets of Old Paris, photographic negatives (18 × 24 cm), artistic documents of fine civil architecture from the sixteenth to the nineteenth centuries; old hotels, historic or curious houses, fine facades, fine doors, fine woodwork, door knockers, old fountains, period staircases. . . . The collection** has today almost completely disappeared; for example, the Saint-Severin quarter. . . . I have the entire quarter, over twenty years, up to 1914, demolition included. . . ."

This is hardly a perfunctory breakdown of subject matter by an ordinary commercial photographer. As a documentary project, Atget's work was more comprehensive than anything previously attempted in European photography; in fact, Atget was the first photographer to undertake the description of a city in such detailed and extensive terms. But he was even more ambitious than that. When he refers to his work as a whole — "This enormous artistic and documentary collection" — Atget joins the idea of documentation to that of art.

Atget's pictures work on both the documentary and artistic level. The vastness of his output, his detailed analysis, his passion for categories — in commercial terms, his inventory, accuracy, and thoroughness — are reminiscent of monumental nineteenth-century analytical works like *The Origin of the Species* or John Ruskin's *The Stones of Venice.* But these same traits were nineteenth-century artistic devices as well. Atget explores a single category — doorways, street vendors — the way Honoré Daumier explores the law courts or marriage. Atget observes like a novelist, and the extended form of his 10,000 photographs, like long nineteenth-century novels, mirrors the world's abundance and variety. If he dissects as finely as Charles Darwin, he conceives as hugely as Honoré de Balzac or Charles Dickens. At the end of his letter to Paul Léon, Atget writes, "I can say that I possess all of Old Paris." And we can add: He possesses the Paris he describes the way Balzac possesses the Paris of the 1830s, as Dickens owns mid-nineteenth century London; that is, as its maker. Atget's Paris is a product of his imagination. Like Balzac and Dickens, he created a world.

It is a vast world, but remarkably ordered, where things fit into traditional categories of history, class, style, age, function. Here is Versailles, there, ragpicker's hovels at Porte de Choisy; this sculpture decorates a church, that, a shop; this angel is Gothic, this Venus, neoclassical; these boots are secondhand, these corsets, new. Atget sifts the large collection of objects and styles we call Paris

**Atget uses the word "collection" for both his negatives and his subjects.

and chooses the best examples for preservation. No display of used boots gleams like his; no old trees cling so tenaciously to the earth. "The grotesque," he wrote beneath a close-up of a bronze head, "the only interesting thing on this little fountain, is a masterpiece of early eighteenth-century ornamental sculpture."

Thus the action of his work takes place against three centuries of French history and taste. But Atget's photography isn't dramatic in the ordinary sense. The vendors who people his streets, for example, rarely take part in the small accidental dramas or perform the vivid fleeting gestures that fill the work of later street photographers. As his tradesmen pose with their goods in empty byways, they are like character actors standing in the wings, dressed in their costumes and carrying their props. The lampshade peddler, festooned with his wares (page 47) is a whimsical figure in a comedy of the streets; the organ-grinder and the singer (page 23), picturesque figures in a romance.

But Atget isn't a narrator, nor does his work have heroes. His individual photographs, which set up the background street by street, shop by shop, are, at the same time, the work's individual episodes. The action of each scene is the process of understanding the world through one's sight. The only real hero of the work is an abstract one — Atget's vision, which can see a shop window as if it were a stage (page 67), or a marble Diana as if she were a living goddess just emerging from the still-swaying trees behind her, about to step off her pedestal (page 69). Atget builds his epic like a novelist, but photographs each scene like a poet. And if his artistry belongs more to the nineteenth century than to ours, so does his theme: the transfiguring power of the imagination.

It is Atget's imagination that recognizes a Parisian shop sign reading *Degustation* — "tasting," "sampling" — as the accidental caption for a flirtation in the square below (page 61); that understands scores of dolls and toy beasts nailed to a ragpicker's shanty in Porte de Choisy (page 57) as an image of fecundity; that can look past an ornamental urn by a reflecting pool to distant trees and see them as growing out of the urn itself, transforming an ornament into a functional object and creating an improbable union between art and nature.

Atget can see all his subjects in terms of metaphor partly because he recognized that the remains of the decorative art he photographed were fictions in their own right. His subject matter isn't simply parks, statues, shops and so forth, but also images. You see them everywhere—the Diana at Versailles, another at Saint-Cloud; flowered curtains in the window behind the organ-grinder (page 23); painted flowers on a bureau in a window display (page 11); a stone clam shell beneath an ornamental urn, and a grinning, bearded face on the urn's belly; bronze horses in *La Fontaine de l'Observatoire* (page 75). For his clients, Atget photographed these objects as artifacts from a specific period, in a particular style; as an artist, he photographed them in terms of their referents — pagan and Christian myths, love, the physical senses, politics, ideas of comfort. He filled his world with these ideas; and by combining them, created a world that has a mythological and political character of its own.

It is a world where art — the mermaid at Versailles, the marble urn — joins nature. It is also a

place where nature approximates the conditions of art by adding images of its own to the world. A beautiful river, for example, mirrors a picturesque old bridge (page 33), making a beautiful new form whose principal characteristic is its novelty, its difference from the original. To Atget, this talent for spontaneous image-making is shared equally by shop windows, the reflecting pools of Saint-Cloud and Versailles, wet sidewalks in Paris, and puddles in formal gardens.

This isn't the same as saying one of Atget's themes is reflection. For as these various reflecting surfaces make new images out of the trees and buildings around them, they become like each other, momentarily dissolving their differences. In Atget's world, reflection is an activity, the way one aspect of nature approximates another.

Things in nature that can't reflect the world can adorn it. Atget photographs a Romanesque arch (page 21) and adds a distant treetop as a fanciful, crowning embellishment to the archway's rigid form. The twisted gesturing tree that screens our view of an old chateau (page 81) adds the romanticism of nature to the nostalgic aura of the castle. Outside a secondhand shop in Paris (page 53), used boots become an ornamental frieze which, to Atget's eyes, includes the cobblestones beneath them. Atget's world decorates itself.

And the decorative art per se that Atget photographs adds natural force and sensuality to his world. Stone fruits teem from the facades of buildings (page 37); horses rear and kick in a still fountain; painted grapes hang over the door of a bistro; and as a stone satyr in a public park unmasks himself (page 45) his body glows with desire.

It is a prolific world, where boots, hats, lampshades, dolls, and statues come in swarms; a generous world, where peddlers bring us their wares; street musicians burst into a spontaneous melody; and shop windows offer fashion in abundance. It is also an erotic world, where love takes several forms, from the coquetry of A. Simon's corset display (page 15) to the frank, grandiose eroticism of Versailles' naked gods and goddesses. A prostitute in short boots, bare legs, a knee-length skirt, and a tawdry fox fur (page 51) is a masterpiece of mixed erotic style, part schoolgirl, part vamp, part jade.

Atget titled this photograph "Versailles." There is little irony here. For Atget's civilization is ultimately democratic. It has lived through the Bourbons, the Revolution, the Empire, the Second Republic; no period or class has a privileged relationship to imagery. Both Versailles' sculpted gardens and flowered curtains in a poor quarter are images of nature; a shaded street and the tree-lined approach to a grand chateau are versions of the same space; photographs of a giant and a midget in a street-fair sideshow (page 11) are images of characters — freaks — who have a place in our mythic imagination alongside satyrs and mermaids.

Atget doesn't blur distinctions. He doesn't confuse the divine love of two Gothic angels with the profane love of prostitutes; or cast-off broken dolls with elegant, bas-relief stone fruits. Nor does he equate the emotional characteristic of his images — the bridge reflected in the river is serene; the trees embellishing the Romanesque arch are tense; the shop windows, which mix reflections of trees and buildings with the mannequins within, are dis-

orienting, disturbing. The images Atget perceives are equal only inasmuch as they are images.

Atget also understands that this equality can exist only in an imaginary world, and occasionally reminds us that his work is a fiction. While his lucid prints seem to open directly onto the scenes they portray, the realistic illusion will sometimes break down abruptly. In some photographs this occurs in the darkened, rounded corners at the top of his frame, which interrupt the description of a sky, the topmost branches of a tree, or a wall. This effect occurs because under certain conditions, the image projected by Atget's lens didn't cover his frame. The vignetting in the upper corners is, literally, where light didn't strike the negatives. Atget's prints are simultaneously, paradoxically, windows onto the world, and descriptions of themselves.

Elsewhere, Atget draws boundaries between nature and illusion, not at the edges, but within his photographs. Here, light becomes indescribably bright, obscuring our vision; there, shadows deepen into impenetrable blackness. In the window of A. Simon's shop, everything is still; but one of the corsets hanging in the doorway waves in the breeze, dissolves into a blur. These ruptures, in otherwise seamless description, mark the farthest reaches of Atget's illusionistic skill. Beyond them, what can be described, is nature; within them, everything that *is* described, has been transformed into art.

And into this artifice that Atget builds out of the past come small hints of the modern world —automobiles, billboards, electric light bulbs, new fashions; just enough to tell us that this fiction is a reverie about a dying era.

Thus Atget's style makes visions, and reminds us that the visions are only fictions, but his realism — his way of making us feel we can enter his pictures simply by stepping over their lower edges — also tells us that those visions are only possibilities of harmony and equality glimpsed by the imagination in the real world. And in contrast to these imagined possibilities, the world that inspires them is frequently sad. Versailles is often gray and desolate; a beautiful reflecting surface is also a sewer; Gothic angels have decayed with time; graffiti covers Louis XIV's marble statuary. The melancholy of Atget's work derives from this poignant distance the contrast between the vision and reality. The speed, accident, and dislocation of our century are conditions for an art based on disjunction, and Atget's art explores combination. Insofar as Atget's work is a fiction, transfiguration is poetic; insofar as it describes reality, change is threatening.

Melancholy, shifting, dying; yet, Atget's work is still consoling. The one pleasure it offers that isn't imaginary is the pleasure of sight; the one democracy of his world that isn't illusory is the democracy of vision. His photographs don't resolve any of the contradictions that confound us or abolish any of the inequalities that oppress us. They tell us, rather, that we needn't accept Louis XIV's—or any ruler's, or, for that matter, any artist's — version of the world as true, any more than we have to reject our own versions of love, nature, or beauty. His photographs encourage us to exercise our own vision, to see the inevitable complexities of this world as the source of our own imaginative understanding.

Ben Lifson

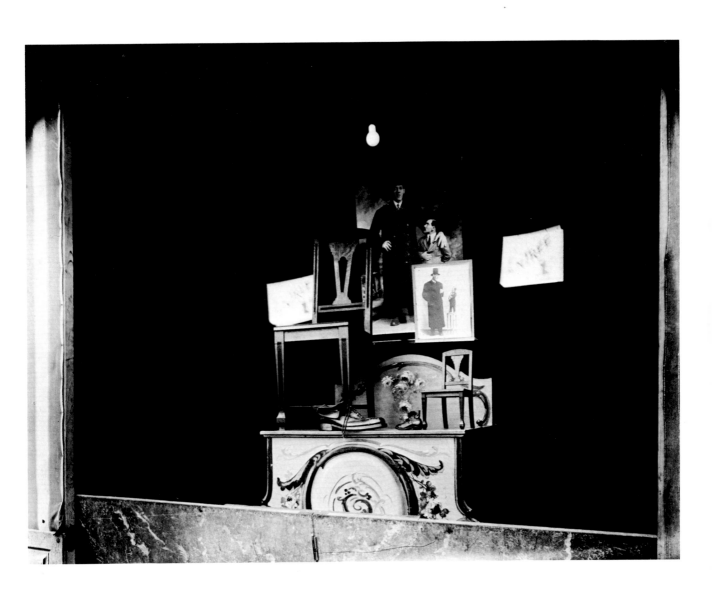

Eclipse, 1911, Arnold H. Crane Collection

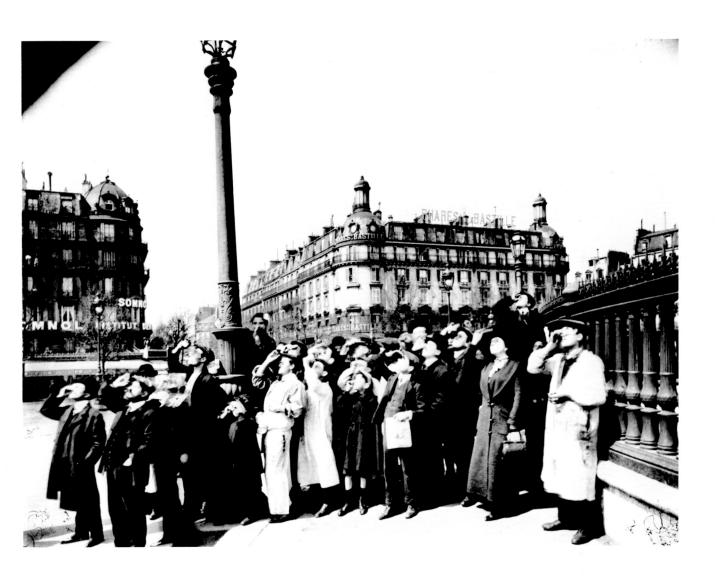

13

Boulevard de Strasbourg, Florence S. Lunn Collection

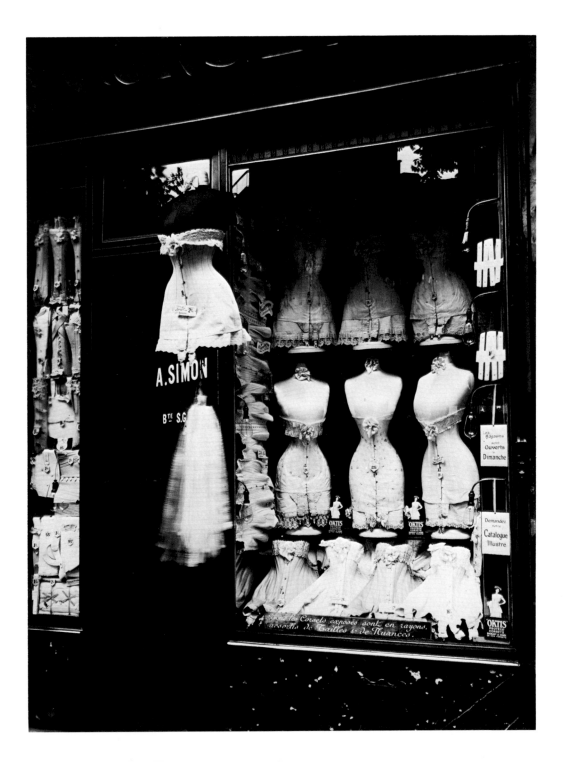

Rue de la Reynée, Philadelphia Museum of Art

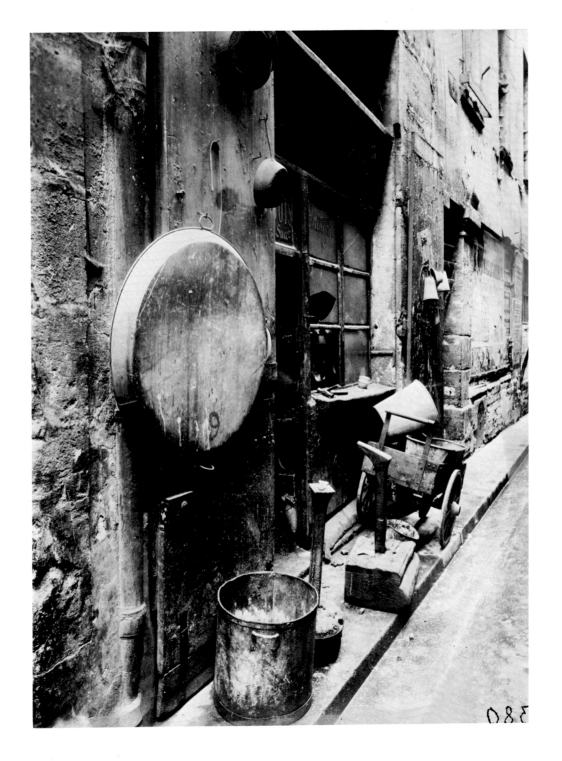

17

Place d'Armes, Saint-Ouen,
Graphics International Ltd., Washington, D.C.

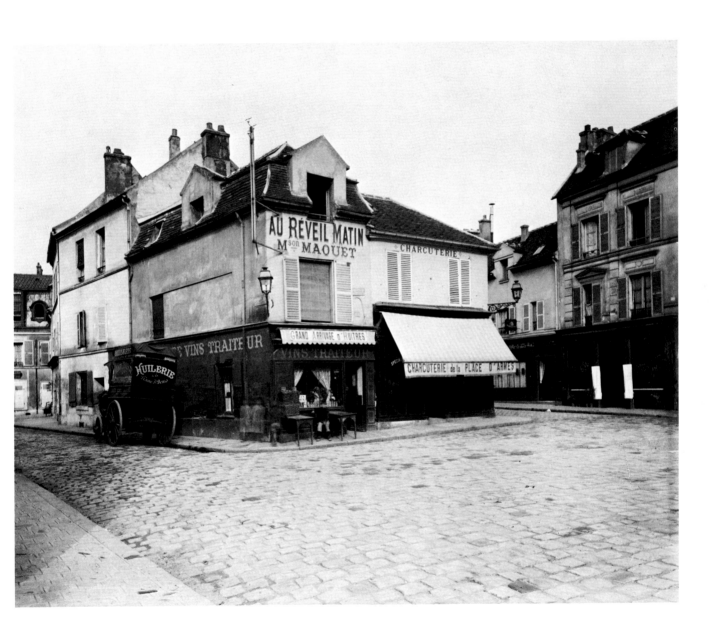

19

Porte Baudry, Monthlery, Leland Rice Collection

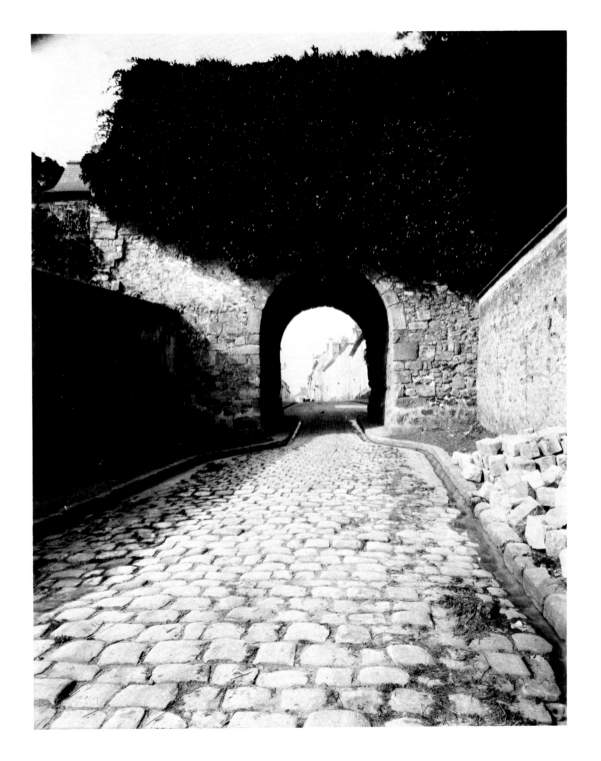

21

Organ Grinder and Street Singer, Philadelphia Museum of Art

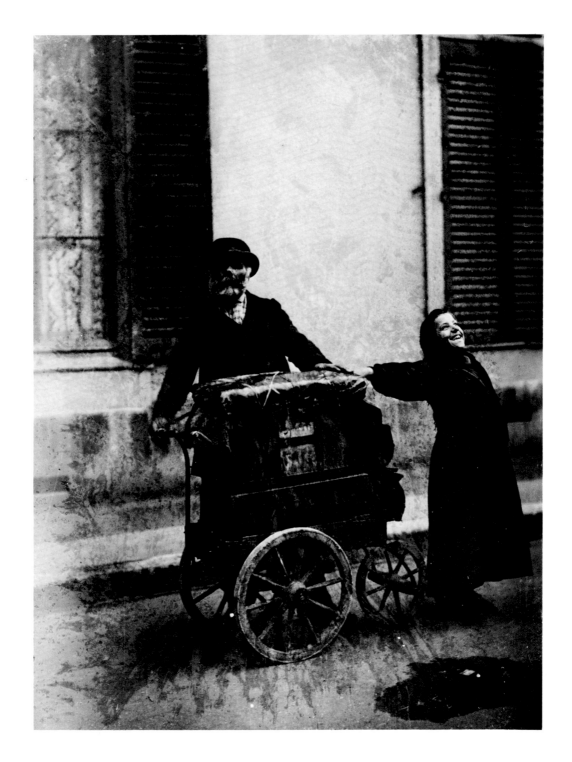

Bar De Cabaret, Arnold H. Crane Collection

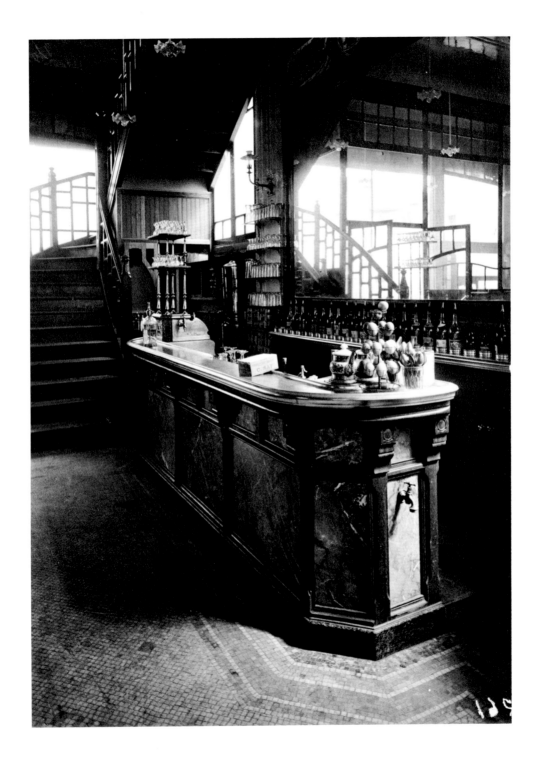

Carrousel, Arnold H. Crane Collection

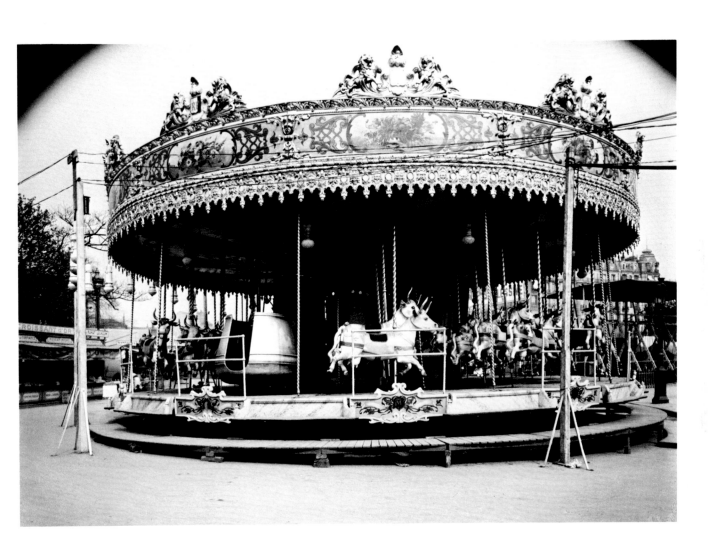

Cour, Arnold H. Crane Collection

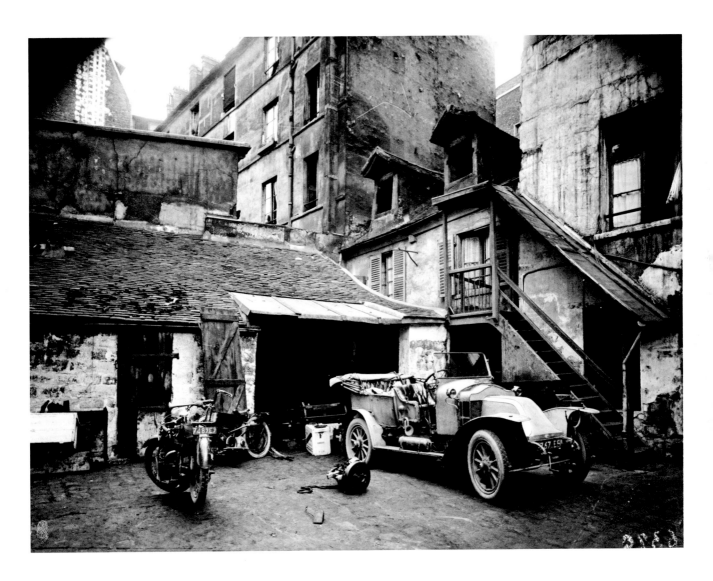

Des Champs, Anthony,
Graphics International Ltd., Washington, D.C.

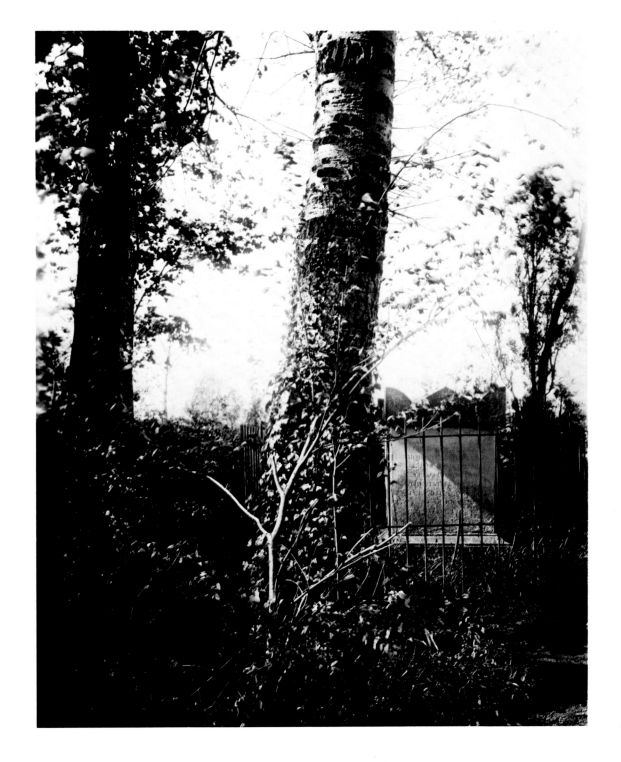

Pont des Belles Fontaines, Juvisy, Dr. David T. Walker Collection

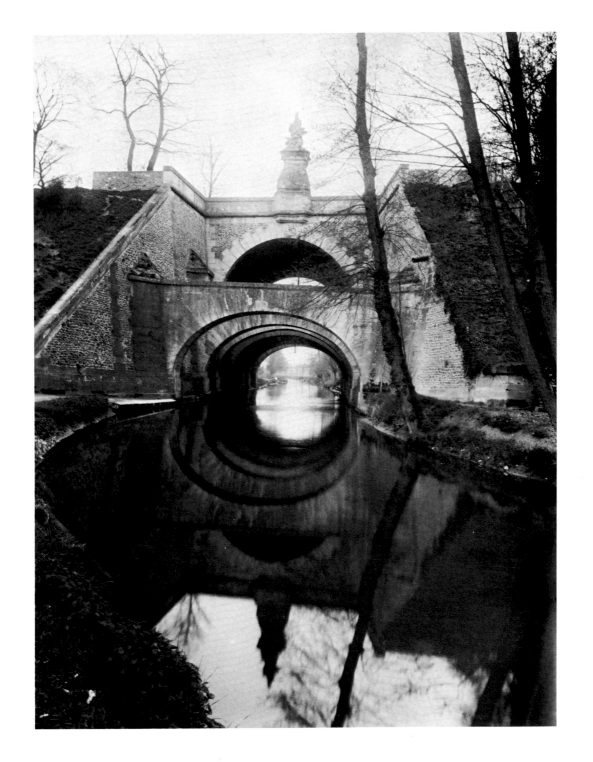

Petit Porche, Rue de Sablé Gelée,
Graphics International Ltd., Washington, D.C.

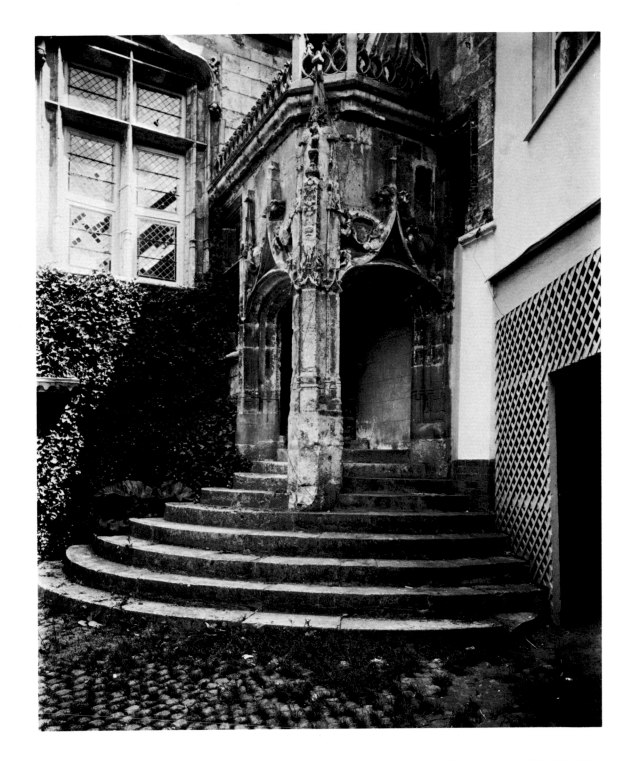

Hôtel Tieubet, Quai des Célestine,
Graphics International Ltd., Washington, D.C.

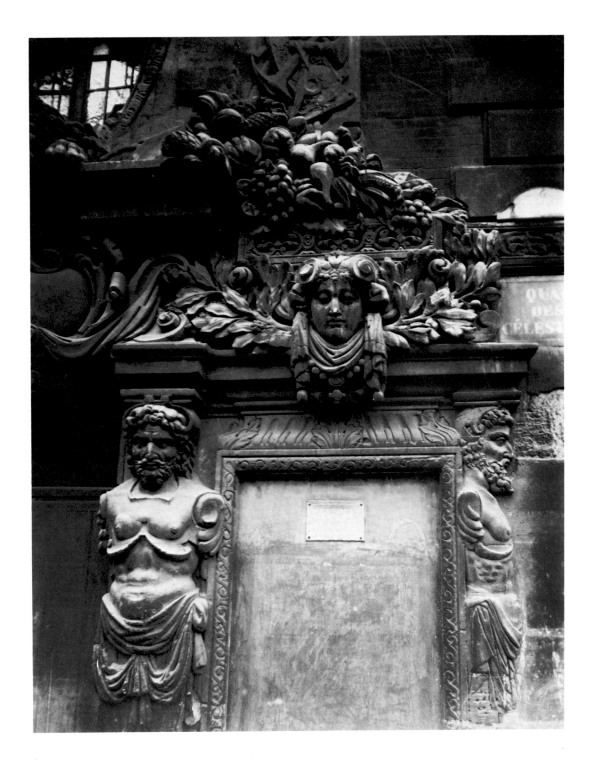

Untitled, Arnold H.Crane Collection

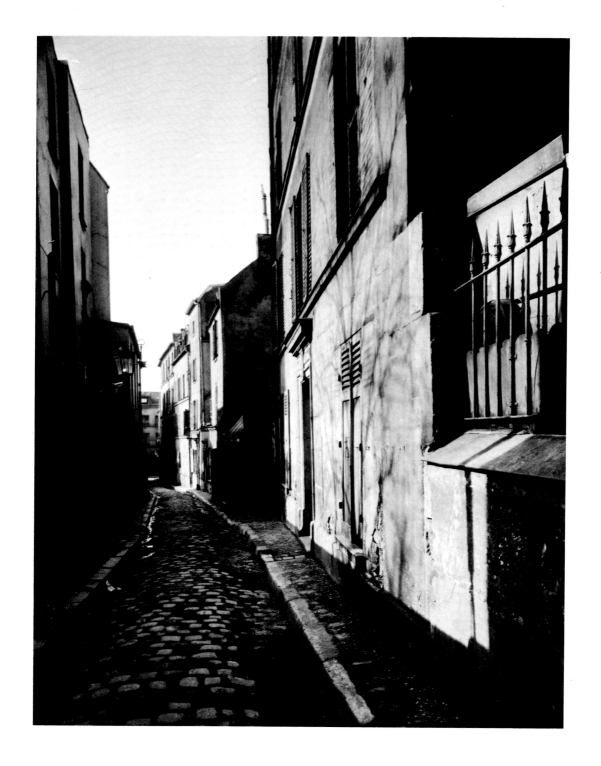

Convent des Carmelites, St. Denis,
Mr. and Mrs. J. C. Tartt, Jr., Collection

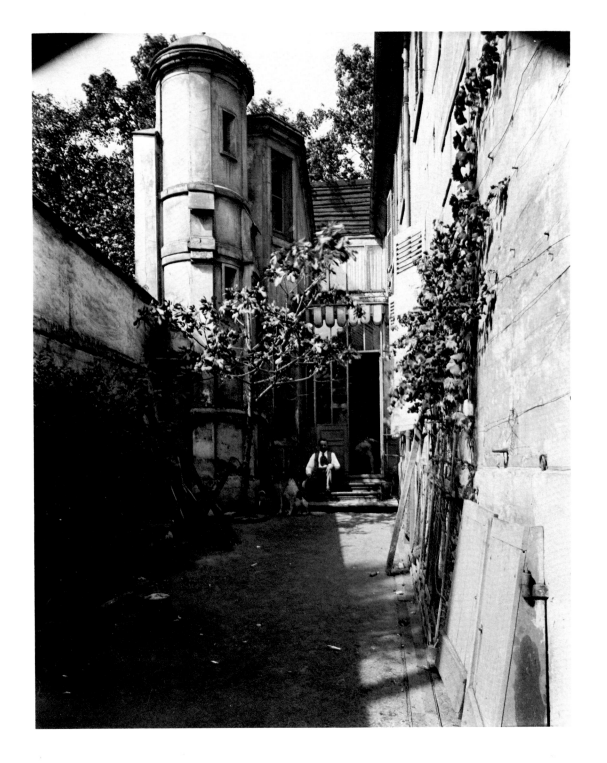

Cour de Parc, Versailles, Gilman Paper Company Collection

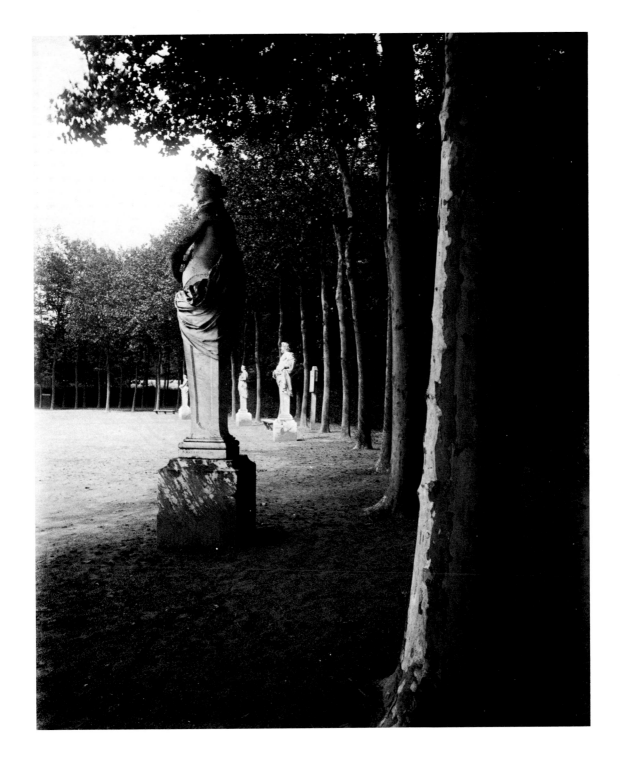

Vertumnus, Tuileries, Philadelphia Museum of Art

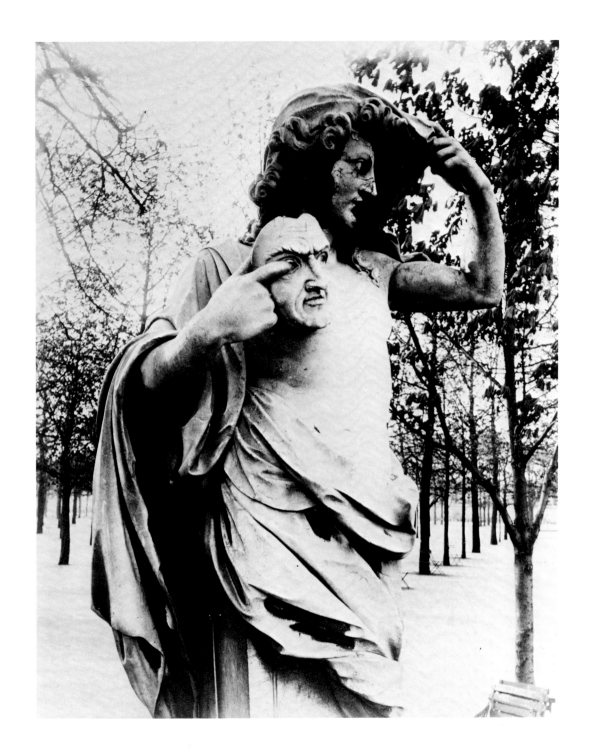

Lampshade Vendor, Christoph A. G. Lunn Collection

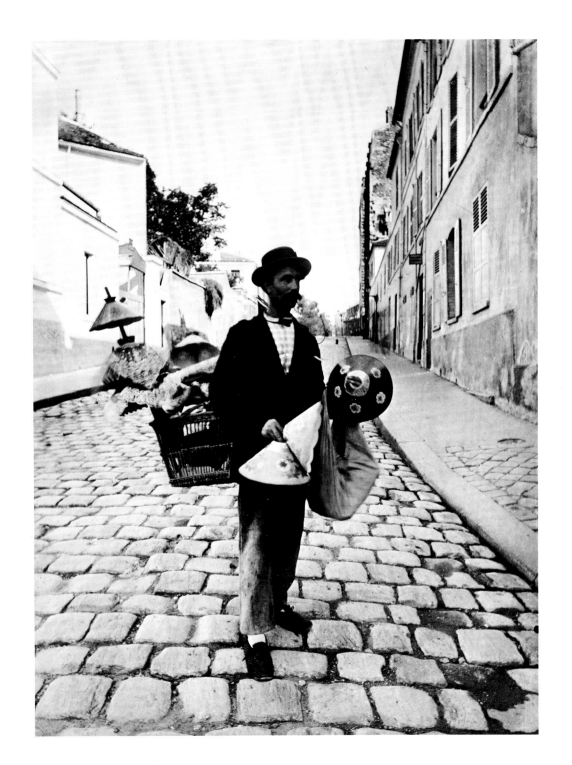

47

Cour Saint Gervais et Protais, Philadelphia Museum of Art

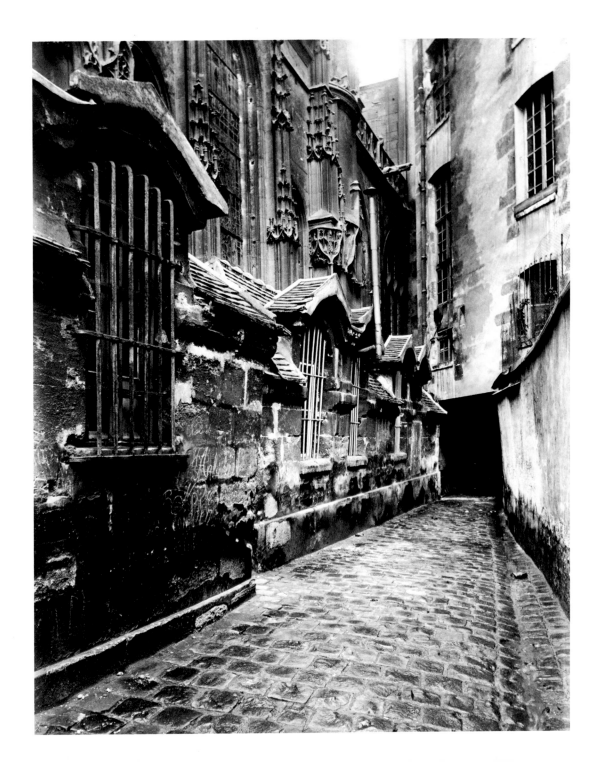

Prostitute, Alexandra N. Lunn Collection

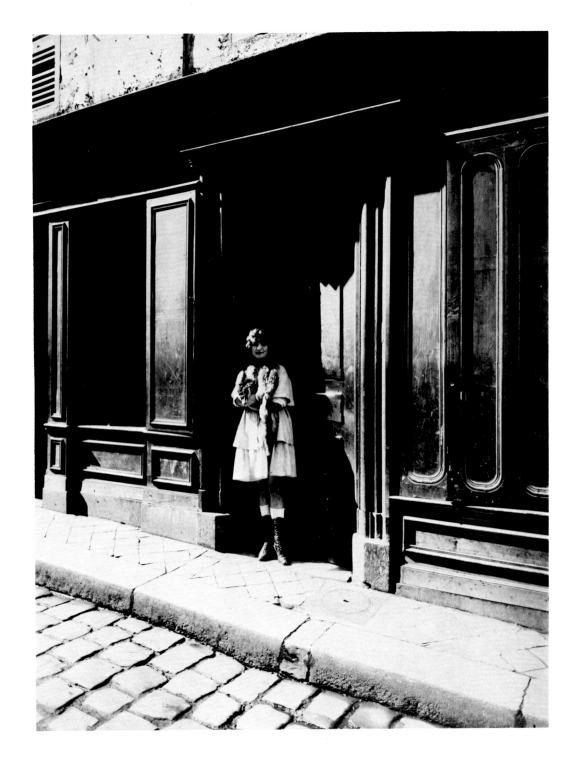

Marché des Carmes, Philadelphia Museum of Art

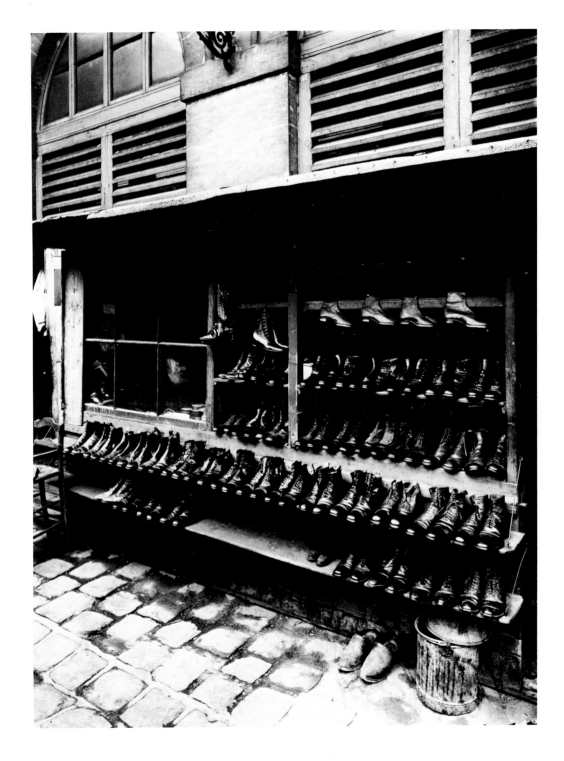

Figaro Populaire, Arnold H. Crane Collection

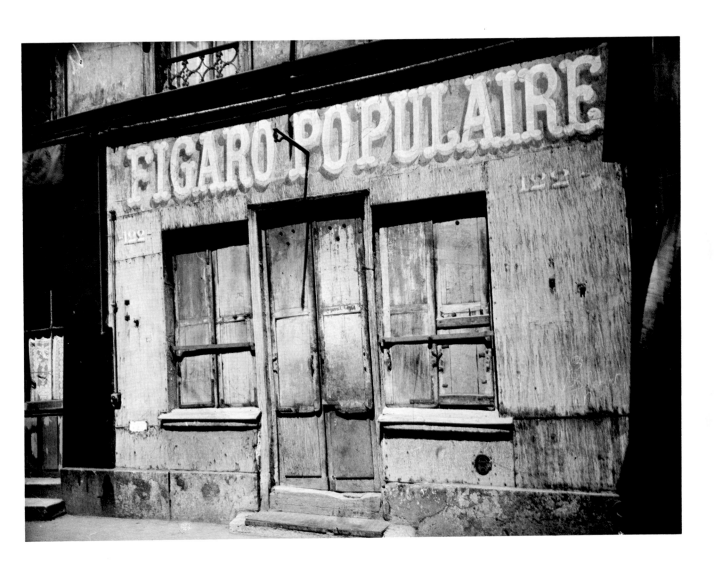

Ragpicker's—Hut, Porte de Montreuil,
Philadelphia Museum of Art

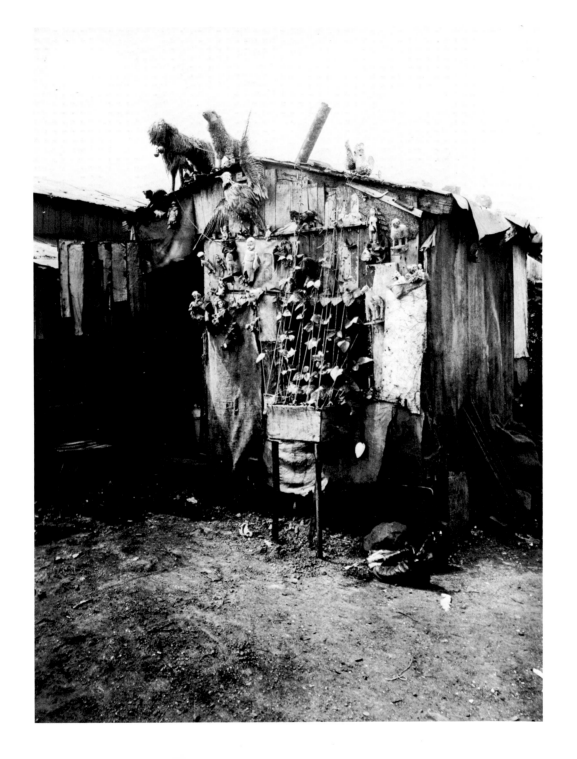

Gentilly-La Bièvre,
Graphics International Ltd., Washington, D.C.

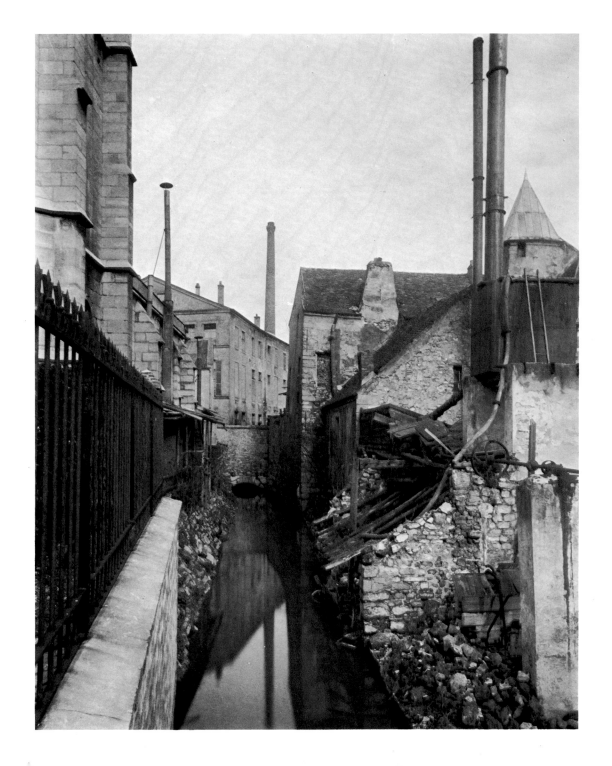

Bread Vendor, Philadelphia Museum of Art

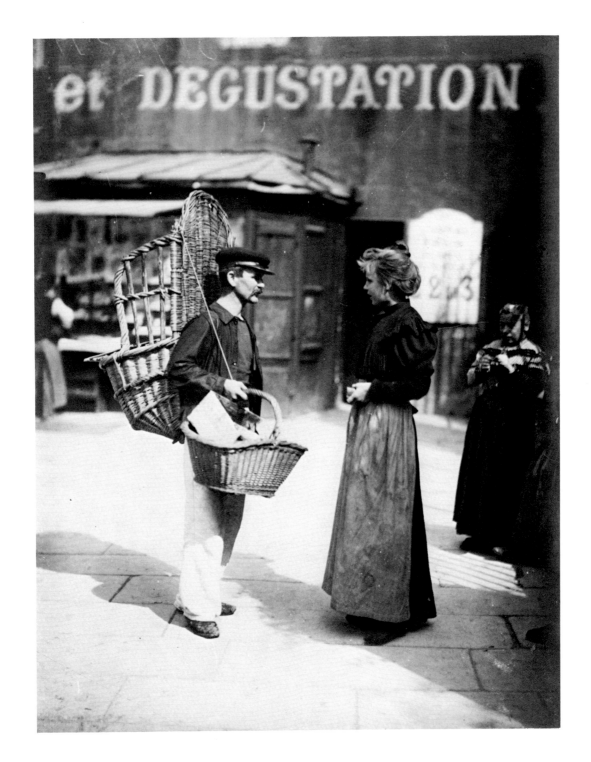

Marché du Temple, Philadelphia Museum of Art

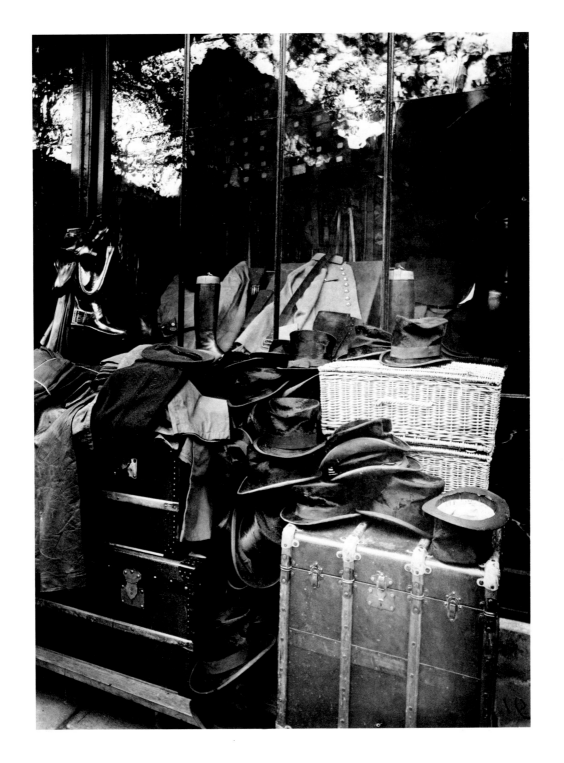

Prostitute, Rue Aselin, Philadelphia Museum of Art

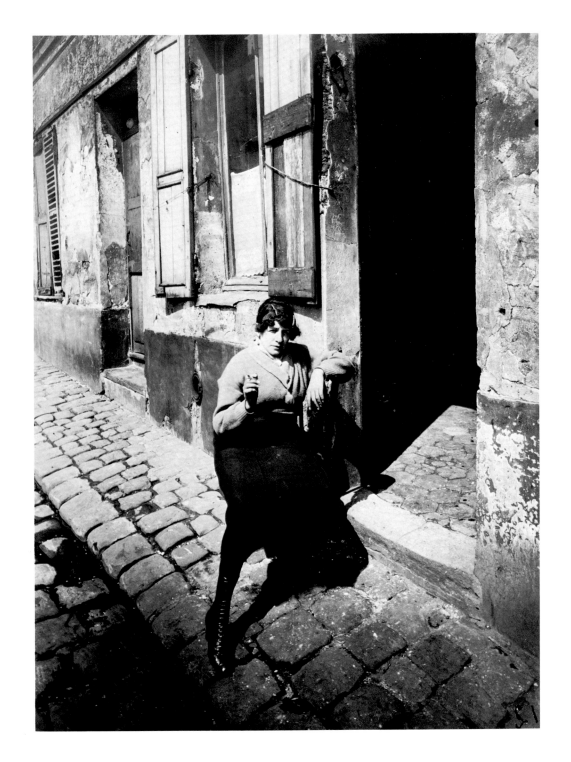

Storefront, Philadelphia Museum of Art

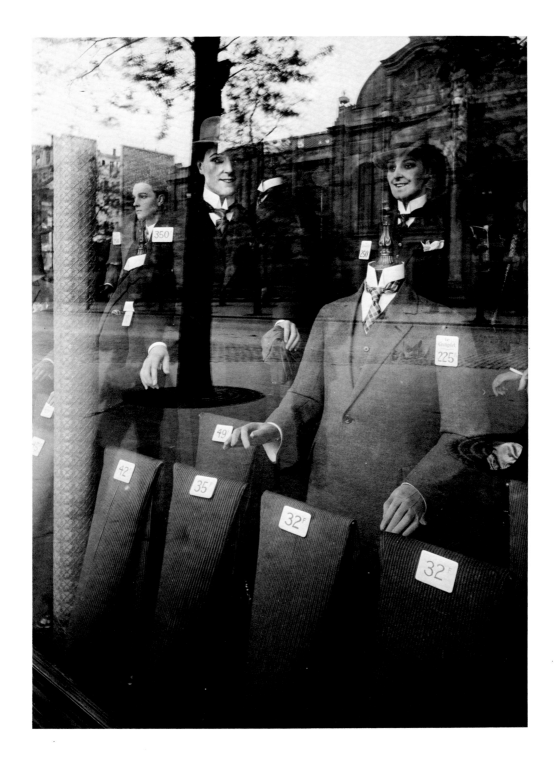

Diana, Versailles, Graphics International Ltd., Washington, D.C.

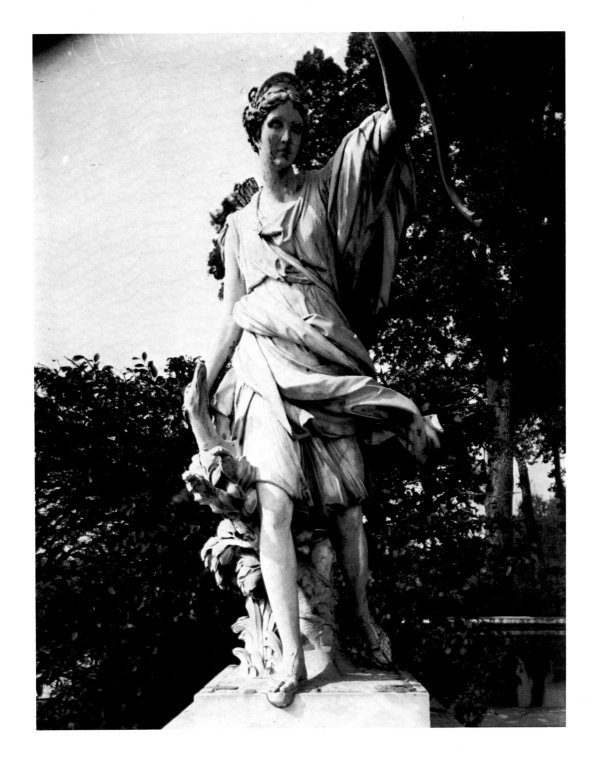

Chateau, Marly-le-Roi,
Ackland Memorial Art Museum, Chapel Hill, North Carolina

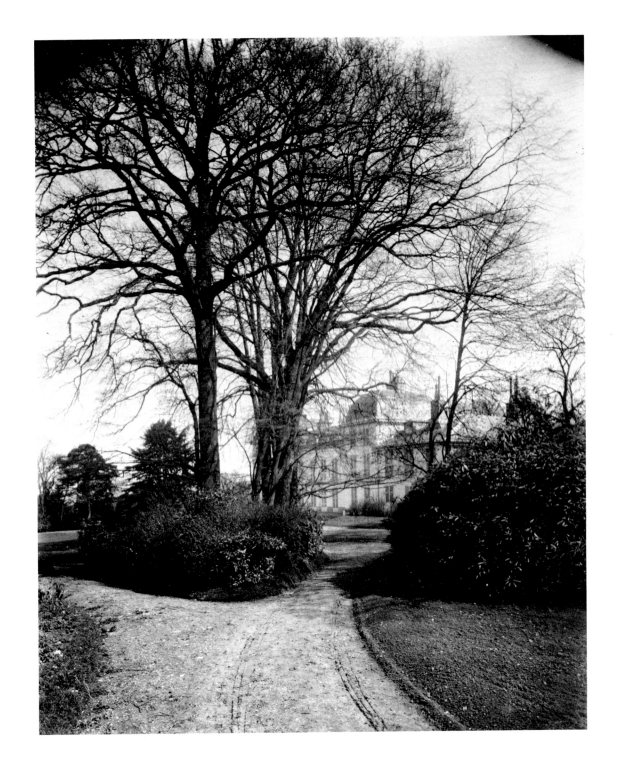

71

Saules, Philadelphia Museum of Art

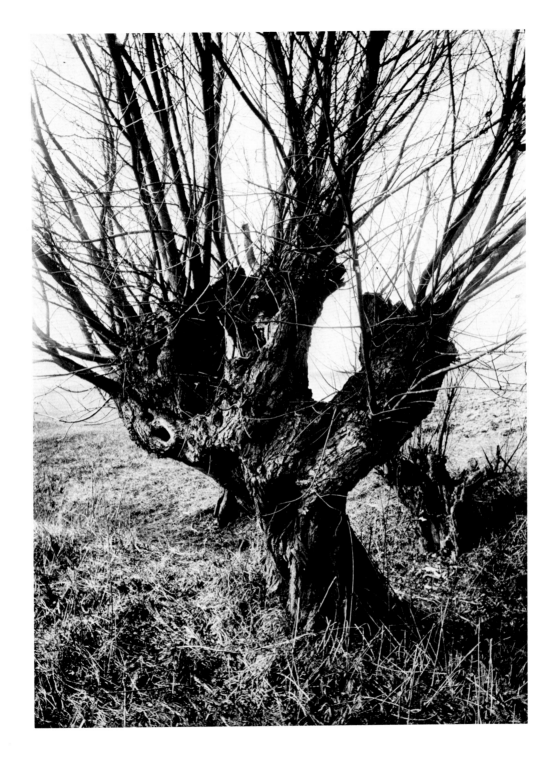

Luxembourg, Graphics International Ltd., Washington, D.C.

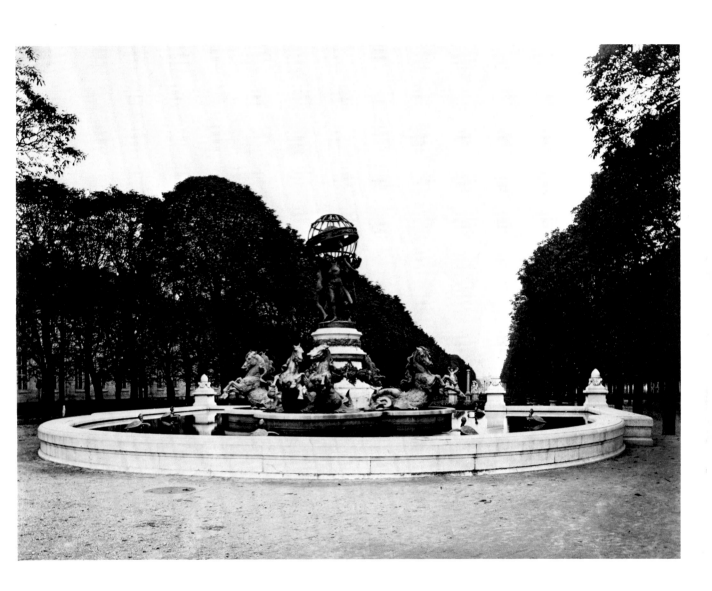

Vielle Rue, Bagneux,
Ackland Memorial Art Museum, Chapel Hill, North Carolina

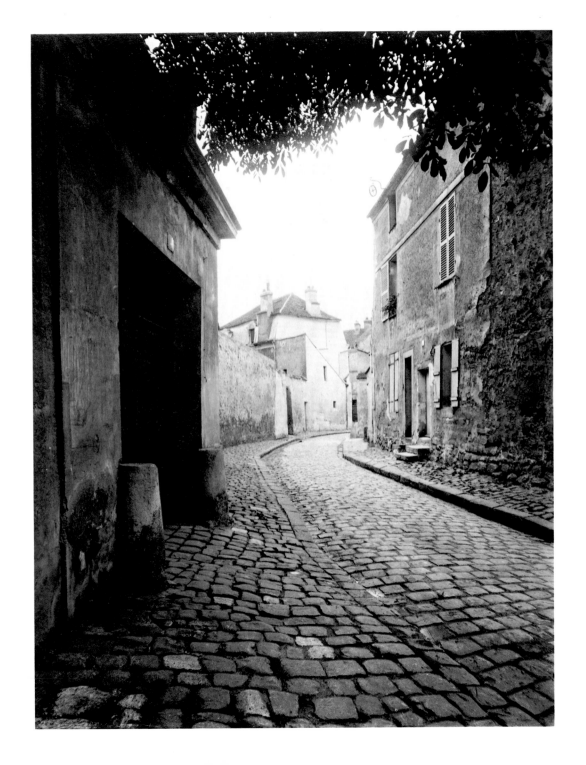

Vielle Maison, Abbeville, Philadelphia Museum of Art

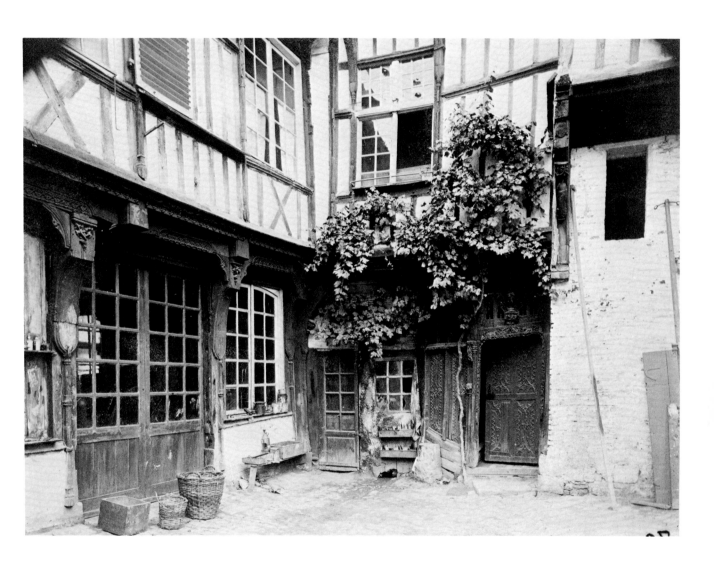

Chateau de Savigny,
Ackland Memorial Art Museum, Chapel Hill, North Carolina

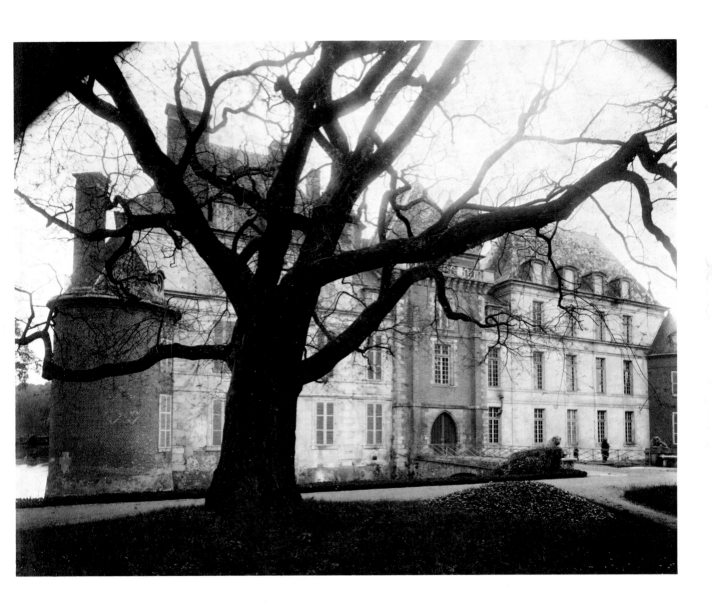

La Marne à Bry,
Ackland Memorial Art Museum, Chapel Hill, North Carolina

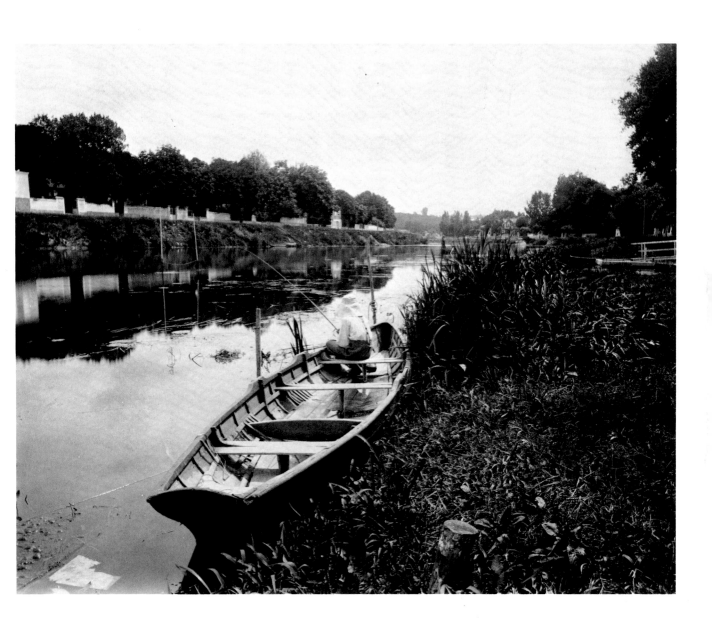

Saint-Cloud, Philadelphia Museum of Art

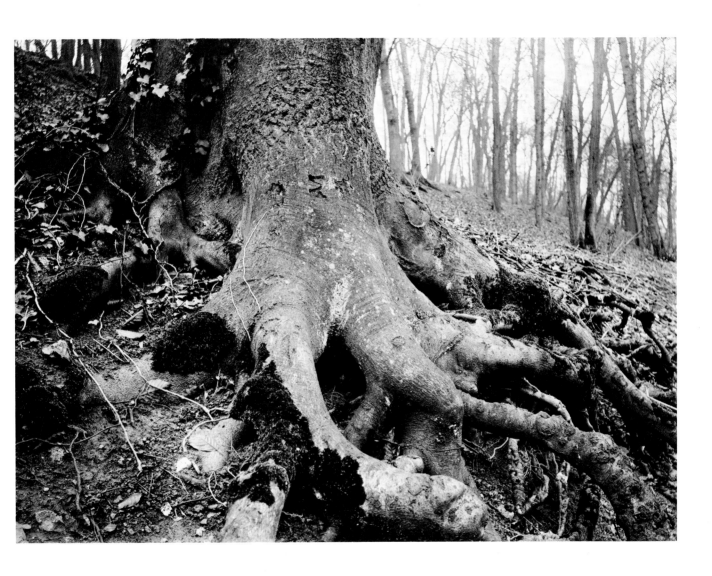

Saint-Cloud, Arnold H. Crane Collection

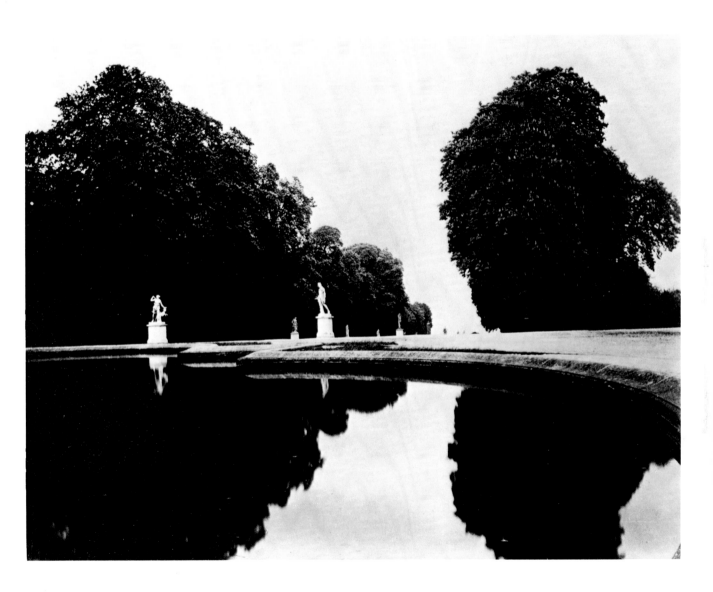

Cerces, Versailles, Graphics International Ltd., Washington, D.C.

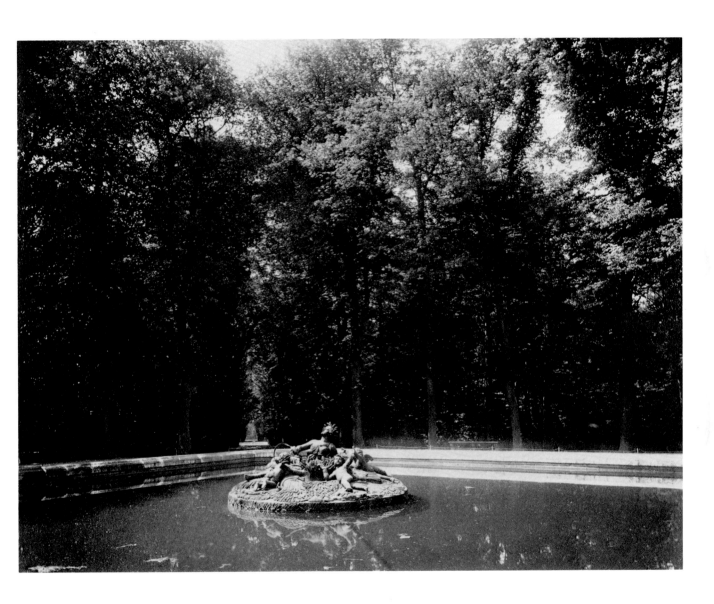

Ancien Palais de Tribunal, Pontoise,
Ackland Memorial Art Museum, Chapel Hill, North Carolina

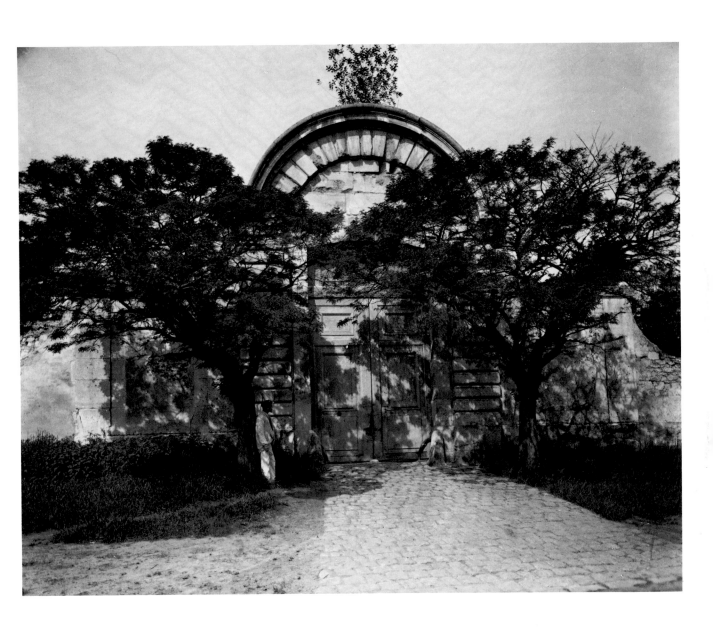

Note on the photographs:

Because Atget himself dated few of his pictures, knowledge of things as essential to an understanding of an artist's work—such as his methods of working or the development of his style—has so far eluded scholars and critics. Research by Barbara L. Michaels of New York University and The Museum of Modern Art, New York, however, recently published in *The Art Bulletin* (Volume LXI, September, 1979), demonstrates that Atget organized his work around four major categories which can be dated:

1. *Vieux Paris,* numbered c. 3000–6731 (1898–1927)
2. *Topographie du Vieux Paris,* numbered c. 10–1700 (c. 1906/07–1915)
3. *Environs,* numbered 6000–7157 (1901–c.1925)
4. *Botanical,* number c. 1–1290 (c. 1898–1920s)

CHRONOLOGY

1857. Eugène Atget born in Bordeaux, the son of a carriage maker.

1857–1859. Orphaned, and goes to live with his uncle, a high official with the French National Railroad, in Bordeaux.

1857–1879. Atget is orphaned early and fostered by an uncle, a successful bureaucrat with the national railway system. According to the uncle's descendants, Atget moves with his foster family to Paris, attends high school, and begins studies for the priesthood. He sails to Uruguay as a cabin boy on a merchant ship.

1879–1881. Studies acting at the Conservatory of the French National Theatre, Paris.

1881–1886. Leaves the conservatory and works as a character actor in second-rate touring companies; tours the provinces and plays in the suburbs of Paris.

1886–1897. In Paris, meets actress Valentine Compagnon, who becomes his lifelong companion; the touring continues, interrupted by a long engagement with a theatre in Grenoble for both Atget and Compagnon.

1897. Valerie Compagnon engaged by a theatre in La Rochelle; Atget and Compagnon settle in Montparnasse.

1898. Atget, frustrated by his unsuccessful acting career, abandons the theatre; tries painting, and fails; turns to photography.

1899. Sells 100 pictures to Bibliothèque, Paris, and discovers market for documentary photographs of Old Paris.

1899–1914. Adds Bibliothèque Nationale, Carnavalet Museum, and other public institutions to his list of customers, and finds private collectors of documents about Old Paris; earns small but adequate living as a photographer; sells picturesque studies to painters, among them Henri Matisse, Georges Braque, Maurice Utrillo, André Derain, Maurice de Vlaminck.

1902. Valentine Compagnon retires from the stage, aged fifty-five; assists Atget with his printing.

1913. Atget lectures on Molière's and Dumas's plays at l'Ecole des Hautes Etudes Sociales, Paris.

1914–1918. World War I; depressed by the War, and in poor health, Atget's productivity wanes; plagued by a stomach ulcer, he resorts to a diet of bread, milk, and sugar, which he observes for the rest of his life.

1918. Productivity increases, but failing health and strained financial situation keep Atget from regaining his former momentum.

1920. Sells 2,600 negatives to Ministry of Fine Arts for 10,000 francs, which eases Atget's and Compagnon's financial situation.

1926. Valentine Compagnon dies at age seventy-nine.

1927. Eugène Atget dies in Paris at age seventy.

SELECTED BIBLIOGRAPHY

ABOUT EUGÈNE ATGET:

Abbott, Berenice, *The World of Atget*. New York: Horizon Press, 1964.

Borcoman, James, "Eugène Atget: A Brief Life." *Eugène Atget: Six Photographs*. Catalog published by National Gallery of Canada, Ottawa, 1979.

Fraser, John, "Atget and the City." *The Cambridge Quarterly*, 3 (Summer, 1968), 199–223; also in *Studio International*, (1900), 232–246.

James, Geoffrey, "Atget and His Legacy." *Eugène Atget: Six Photographs*. Catalog published by National Gallery of Canada, Ottawa, 1979.

Katz, Leslie, "The Art of Eugène Atget." *Arts Magazine*, 36 (May–June, 1962), 35.

LeMagny, Jean Claude, "Eugène Atget, 1857–1927." *Creative Camera International Yearbook, 1975*. London: Coo Press, Ltd., 1975, 1956.

LeRoy, Jean, "Atget et Son Temps, 1857–1927." *Terres de'images*, 5/6, no. 3, (1964), 357–372.

—————*Atget, Magicien du vieux Paris en son Epoque*. Paris: Pierre Jean Balbo, Éditeur, 1975.

MacOrlan, Pierre, Preface to *Atget, photographe de Paris*, by Berenice Abbott, (ed.). New York: E. Weyhe, 1930.

Michaels, Barbara L., "An Introduction to the Dating and Organization of Eugène Atget's Photographs." *The Art Bulletin*, 61, (September 1979), no. 3, 459–467.

Szarkowski, John, "Atget's Trees." *One Hundred Years of Photographic History: Essays in Honor of Beaumont Newhall. Edited by: Vandoren Coke*. Albuquerque, New Mexico: 162–168, 1975.

Trottenberg, Arthur D., Introduction to *A Vision of Paris: the Photographs of Eugène Atget, the Words of Marcel Proust*. New York: MacMillan & Co., 1963.

ABOUT EUGÈNE ATGET'S SUBJECTS:

Adams, William Howard, "The Gardens," Introduction to *Atget's Gardens*. New York: Doubleday & Co., Inc., 1979.

COLLECTIONS OF ATGET'S PHOTOGRAPHS

Trottenberg, Arthur D., (ed.), *A Vision of Paris: the Photographs of Eugène Atget, the Words of Marcel Proust*. New York: MacMillan & Co., 1963.

Adams, William Howard, (ed.), *Atget's Gardens*. New York: Doubleday & Co., 1979.

Abbott, Berenice, (ed.), *Atget, Photographe de Paris*. New York: Horizon Press, 1930.

—————*The World of Atget*. New York: Horizon Press, 1964.

Martinez, Romeo, (ed.), *Eugène Atget*. Milan: Electra Editrice, 1979.

Eugène Atget: Six Photographs. Catalog published by the National Gallery of Canada, Ottawa, 1979.

APERTURE Masters of Photography

The Aperture Masters of Photography series provides a comprehensive library of photographers who have shaped the medium in important ways.

Each volume presents a selection of the photographer's greatest images. 96 pages, 8 x 8 inches, 42 black-and-white photographs; hardcover, $12.50. The set of twelve titles, a $150 value, is available for $99.95 and can be purchased through fine bookstores.

If unavailable from your bookseller, contact Aperture, 20 East 23rd Street, New York, NY 10010. Toll Free: (800) 929-2323; Tel: (212) 598-4205; Fax: (212) 598-4015.

A complete catalog of Aperture books is available on request.

BERENICE ABBOTT

Essay by Julia Van Haaften

EUGENE ATGET

Essay by Ben Lifson

MANUEL ALVAREZ BRAVO

Essay by A. D. Coleman

HENRI CARTIER-BRESSON

Essay by Henri Cartier-Bresson

WALKER EVANS

Essay by Lloyd Fonvielle

ANDRE KERTESZ

Essay by Carole Kismaric

MAN RAY

Essay by Jed Perl

AUGUST SANDER

Essay by John von Hartz

ALFRED STIEGLITZ

Essay by Dorothy Norman

PAUL STRAND

Essay by Mark Haworth-Booth

WEEGEE

Essay by Allene Talmey

EDWARD WESTON

Essay by R. H. Cravens